LIDOÑA WAGNER

PILGRIMAGE

WONDER ▪ ENCOUNTER ▪ WITNESS

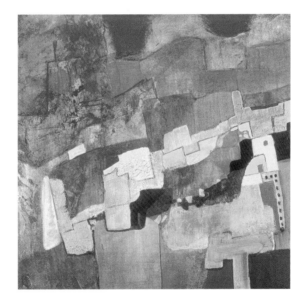

PILGRIMAGE

WONDER·ENCOUNTER·WITNESS

This project was made possible through the generous assistance of many persons, including but not exclusive of the following: Pamela and Terry Bergdall, Bill and Clare Bonnell, John Burbidge, Susan Burnes, Karen Campbell, Diane Dunlap, David Dunn, Carole Gardner, Laura Golden, Nancy Golden, Roger Guthrie, Judith Hamje, Kathleen Heinz, Phyllis and Len Hockley, Sharry and Wesley Lachman, Katherine Chang Liu, Tim Lush, Sharon Maribona, Victoria Martinez, Kip May, Aleta McGee, Linda Mears, Joel and Terry Narva, Sandi and Walt O'Brien, Petie Padden, Kamala and Vinod Parekh, Theresa Pearson, Bruce Robertson, Gloria Santos, Kim Sherman, Mimi Shinn, Karen Snyder, Elaine and John Telford, Kathy Tiger, Rocio Torres, Lillian Winkler-Rios, Verna Wise, Tim Wegner
Special thanks are due: The Institute of Cultural Affairs, whose mission took me to the heart of humanity.

Published by LiDoña Wagner Studio, www.lidonawagner.com
ISBN# 9780983641407

Cover, section pattern, and all story art: Detail from LiDoña Wagner paintings
Site photographs reprinted with permission of photographers
Art Photos by O'Brien Imaging
Cover and Book Design by Laura Golden

i

For my granddaughters,
Anna Mahala and Merron Claire Woodbury

May joy and creativity fill your personal pilgrimage!

Li Tova

CONTENTS

Other Painting Series by LiDoña Wagner

STONE AGE

TRANSITIONS

COLOR OF JOY

www.lidonawagner.com

FOREWORD

It has been my pleasure to follow LiDoña Wagner's work and observe the dedicated and meaningful development of her current series.

Based on her life in villages around the world, LiDoña treats each place with care for what is authentic to it. With an artist's sensitive eye and a philosopher's astute mind, she uses symbolism, as well as the forms and colors from her memory, to pay tribute to these different cultures.

The tapestry of colors and patterns represents LiDoña's signature backdrop in these paintings. Her flexibility with symbolism and whimsy fortifies the way she expresses the content.

LiDoña uses a layering process in her paintings that gives color variance – her chosen colors have a multitude of warm and cool layers. Her neutral colors are rich and her rich colors are neutral.

Her unique way of using patterns and textures to suggest differences in various farming cultures is both heart-felt and effective. The high contrast in her patterns works well with her more organic landforms. She employs her personal proportions for space division to express her insight and vision. Her work is orderly, yet it also has a whimsical quality.

LiDoña's work is poetic, requiring some effort from the viewer. But engaging with each painting will be well rewarded. Everything looks fresh to us because it's something we haven't seen before.

- Katherine Chang Liu

INTRODUCTION

PILGRIMAGE

To go on a long journey ... to confront obstacles ... to be grateful for kindnesses

To do penance ... to pay homage ... to find meaning

To seek answers to one's deepest questions ... to find one's self through testing

To see the world ... to know the world ... to become the world

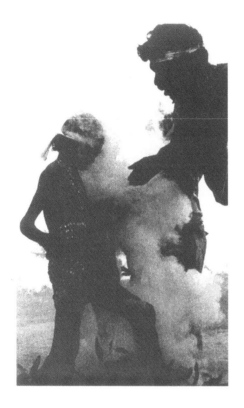

Human beings have an innate urge to know themselves, to understand their environment, and to become familiar with those who appear to be different from them. Whether born into ancient tribal times, Chaucer's middle ages, or the contemporary era, numerous persons have sought this knowledge by embarking upon pilgrimages to sites both close at hand and far away.

The paintings and stories in *Pilgrimage* are the product of forty years of wanderlust – a passion that arose at the age of seventeen when I left my blue-collar home in Midwestern United States. I embarked upon a quest that took me to places around the world where I encountered peoples and cultures that have survived for thousands of years.

Having come of age during the upheaval of the sixties, my curiosity about the world and love of learning drew me to the work of the Institute of Cultural Affairs, a voluntary Peace Corps-style organization committed to empowering grassroots people in impoverished communities around the world.

Mowanjum, Western Australia

4

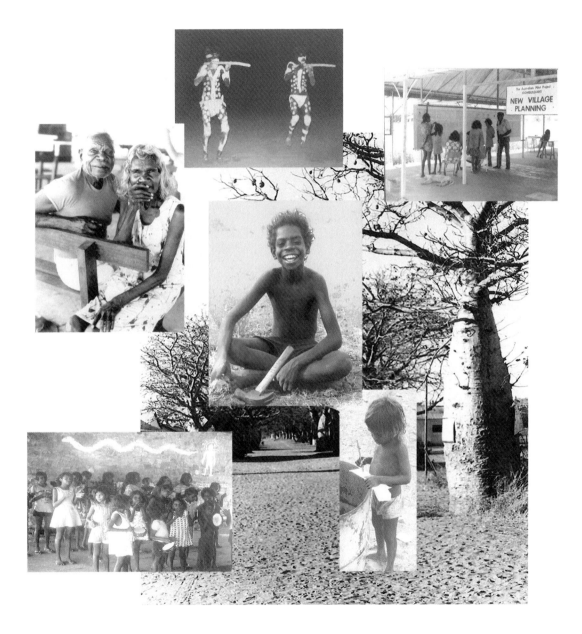

Mowanjum and Oombulgurri, Western Australia

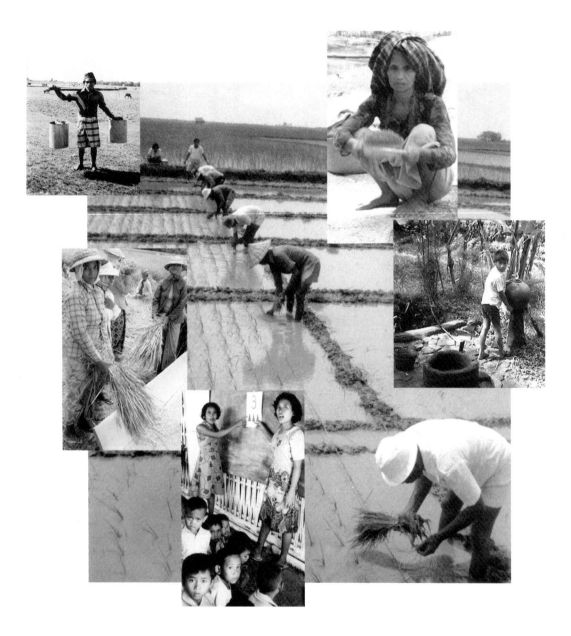

Bontoa and Kelapa Dua, Indoesia

6

From 1968 to 1988, I helped launch and implement community development projects focused on primary health care, literacy and education, economic ventures, community organization and cultural cohesion. I documented and evaluated these projects, engaged in international fundraising for this work, and trained indigenous people to write grants and set up documentation systems.

Communities that chose to become human development projects viewed the presence of my colleagues and me as hope for a better life. We gave our time, energy, and limited knowledge. When we took village people to speak with government officials and taught them to present their needs and convey their commitment, they discovered self-respect and pride. As we worked with all levels of society, people came to see one another with new eyes. For many women, I was the first female they had ever witnessed living and operating as an equal to men.

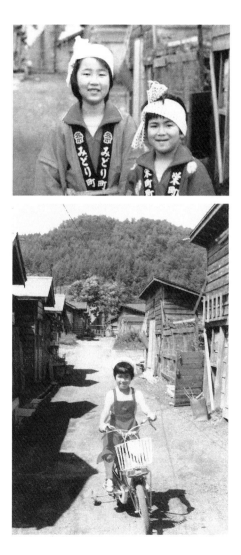

Oyubari, Japan

7

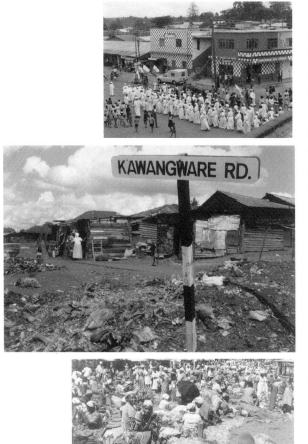

There were many obstacles and many defeats. I was often frightened, uncomfortable, and challenged beyond my skills and capacity. It was heartbreaking to see floating ghettos, mud houses, legless persons begging from skateboards, women bruised from beatings, children in rags, flies on the eyes of babies, women and children carrying water over long distances, and emaciated men pulling carts piled high with materials.

I traveled on buses that were packed-to-the-gills, sharing dirt roads with donkeys, cows, chickens, elephants, dogs, monkeys, camels, bicycles, and motorcycles. I lived through monsoon rains, typhoons, heat that killed the vulnerable, having my bus attacked and burned by rebels, and oh so much more. It was easy to be discouraged and to question the efficacy of what we were doing.

Kawangware, Kenya

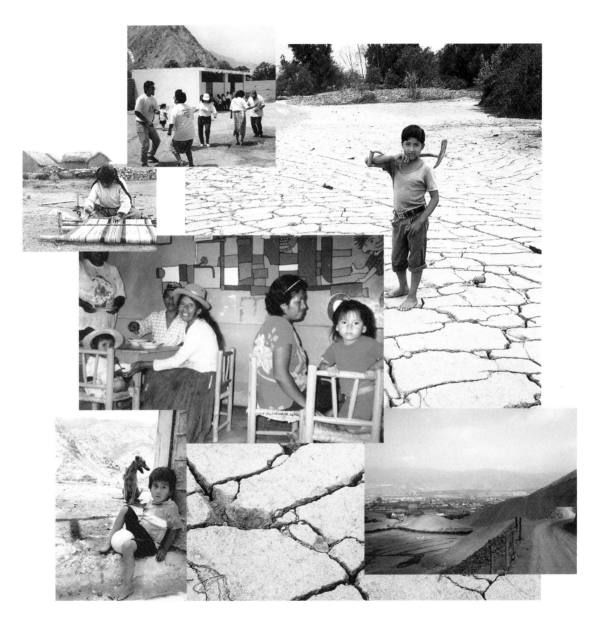

Azpitia and Lunahuana, Peru

9

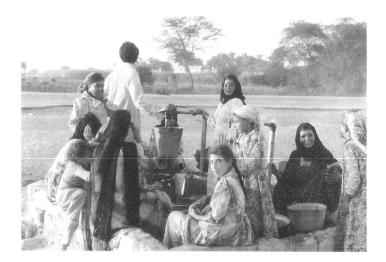

When I look back, it is clear that I received more than I was capable of giving. I am endlessly amazed by and grateful for the hospitality with which I was received. I treasure the people I met. Visual memories continue to fill me with delight: temples built among rolling hills, waving wheat fields, ascending rice terraces, colorful markets and fabrics, and a cacophony of saris drying by the river.

I experienced exuberant festivals, spontaneous dances, tantalizing music, deliciously flavorful food, and the tastiest teas imaginable. I came to appreciate ancient traditions and communal values. These became a lens through which to view myself and western culture. As my ignorance and bigotry were exposed and expunged, I made lifelong friendships that span the globe.

Bayad, Egypt

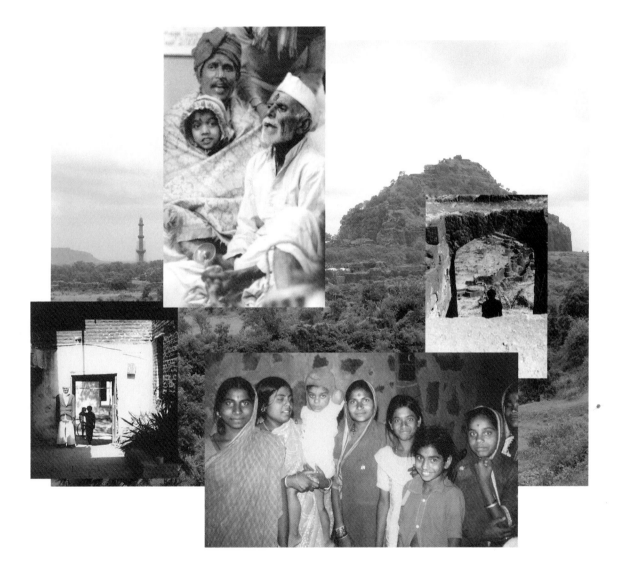

Maliwada, India

The photographs on these pages were taken by colleagues with whom I worked around the world. Throughout my two decades of international work, I owned neither a camera nor a sketchbook. But the experiences were so deep, emotionally moving, and rich with meaning, that they left indelible images and impressions upon my psyche. It is from this well of real life memories that I have created the paintings and anecdotal stories in *Pilgrimage*.

Seen through my eyes, *Pilgrimage* is about places that evoked wonder in me, encounters that challenged me to face myself, and people whose courage and ingenuity I was privileged to witness.

I hope *Pilgrimage* will:
Reveal the mystery and beauty of unfamiliar places
Honor a variety of the world's cultures
Evoke questions about universal human experience

PILGRIMAGE SITES

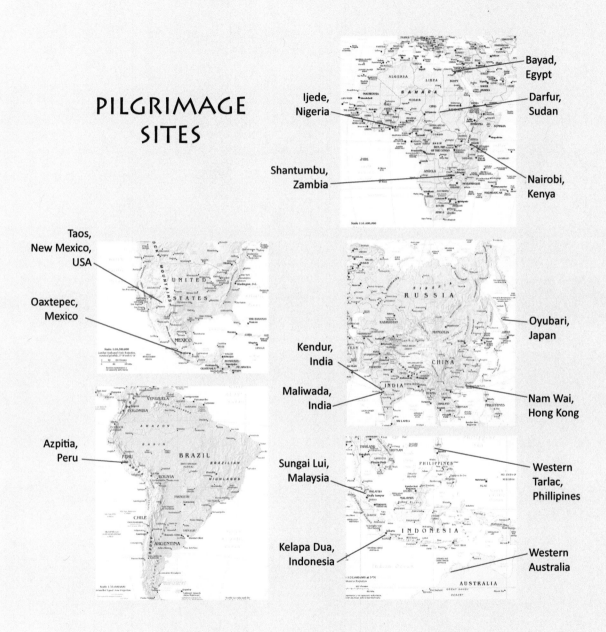

Bayad, Egypt

Ijede, Nigeria

Darfur, Sudan

Shantumbu, Zambia

Nairobi, Kenya

Taos, New Mexico, USA

Oaxtepec, Mexico

Oyubari, Japan

Kendur, India

Maliwada, India

Nam Wai, Hong Kong

Azpitia, Peru

Sungai Lui, Malaysia

Western Tarlac, Phillipines

Kelapa Dua, Indonesia

Western Australia

13

PILGRIMAGE PAINTINGS
WONDER

CELEBRATE THE VILLAGE
Taos Pueblo, New Mexico

The adobe appeared to be all of one piece.
Like sensuous folds in a section of cloth, it stretched
from the foot of the mountain, around the valley,
and up the rolling hills. Over centuries, in spite of the
ebb and flow of invading peoples, Taos Pueblo
kept its traditions continuously alive.

2006 20" x 30" Acrylic on paper From the collection of Joel and Terri Narva

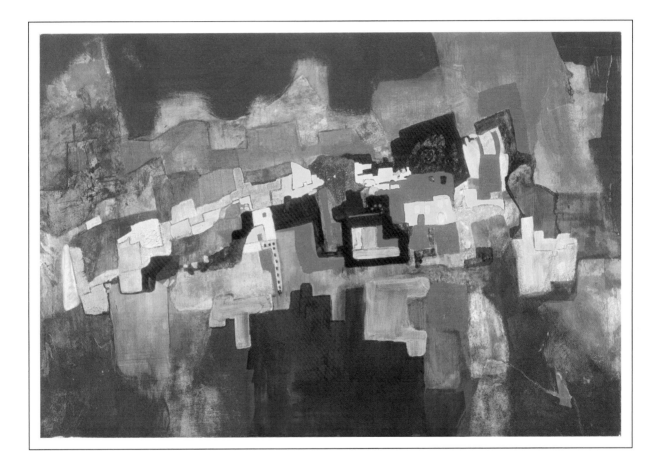

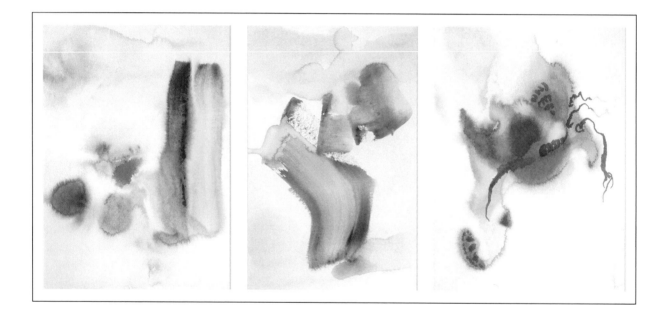

18

WALKABOUT TRIPTYCH:
AYERS ROCK/ULURU, BOOMERANG,
MEDICINE BAG
Western Australia

As the train left the outskirts of Sydney and
rumbled toward Melbourne, I saw bleached bones poking up
from an endless expanse of barren land. I wondered,
"How did the Aboriginal people survive for
40,000 years in this environment?"

2000 Each image 10" x 15-18" Watercolor

BLESSED RAIN
Sungai Lui, Malaysia

Water showered from above, sparkling like crystals
all around us, as we frolicked beneath the waterfall.
Around us were trees draped with guavas and breadfruit.
Beyond them, rice fields shimmered in the sunlight.
All paths led to the school compound.

2007 20" x 30" Acrylic/Collage on paper

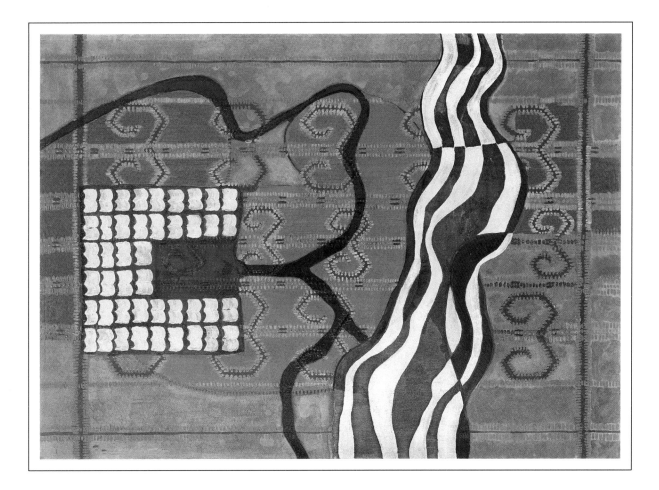

BEASTS OF BURDEN
Western Tarlac, Philippines

Terraced fields spiraled around steep ascents of
cloud-covered mountains. Climbing among the terraces
were women wrapped in red cloth woven with ancient
patterns – on their backs, sticks for fuel,
water jugs, babes to suckle.

2008 Two images, each 8" x 10" Acrylic/Gold foil on illustration board

UNDESERVED KINDNESS
Azpitia, Peru

Cracked brown earth, blowing dust, and thin air
gave the appearance of the surface of the moon.
Yet, Azpitia totally charmed me with its small
adobe homes all painted white, women in
clothing made of traditional hand-woven cloth,
roads swept clean, and small corner stores.

2009 20" x 32" Acrylic/Collage on Bristol board

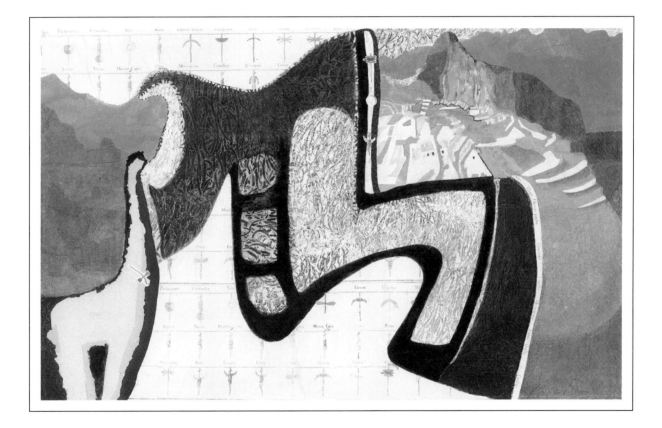

25

HALF YET TO LIVE
Oaxtepec, Mexico

Moments before, a sunset of lavender and rose
had moved me to tears. Breathing scents of
magnolia, pine, and sage, I gazed at moonlit
reflections in a pool of water. Stars were coming out
overhead, one by one. I felt an urge to alter
the trajectory of my life.

2006 25.25" x 14" Acrylic on illustration board

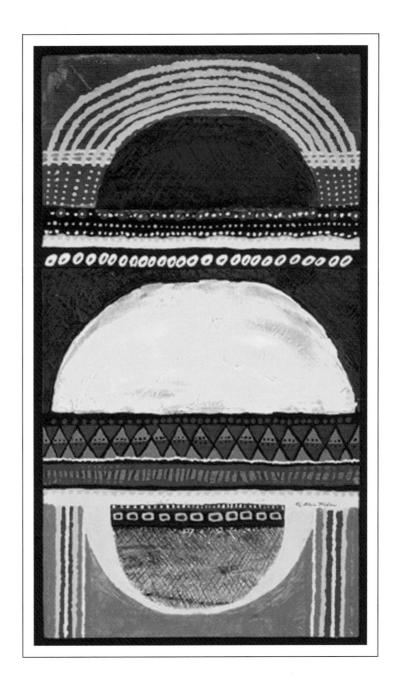

ENCOUNTER

WHERE'S THE FERRY?
Ijede, Nigeria

I was informed that the maze-like quality
of the village was intentional; it prevented
outside enemies from being able to find and murder
the chief. Organization being my forte and essential
to my sanity, the labyrinth of buildings took me
completely outside my comfort zone.

2008 20" x 30" Acrylic on Bristol board

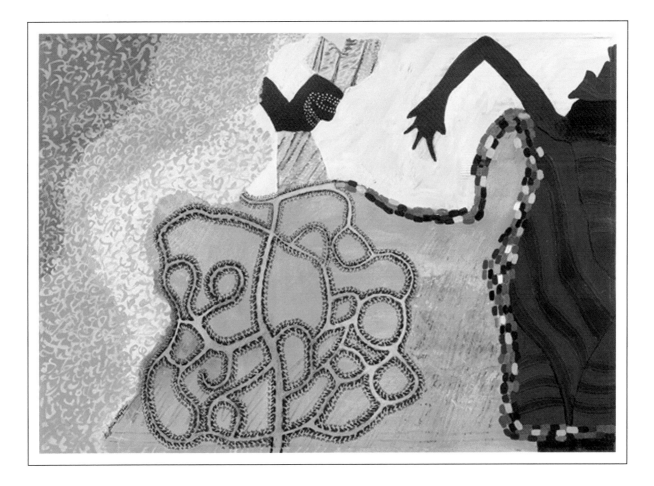

LIFTING THE SHADOW
Kelapa Dua, Indonesia

Suddenly a six-foot hulk rose up
yelling a string of swear words. Grasped by
the neck, I struggled to break free. He began
pressing his thumbs into my throat. Do Indonesian
shadow puppets reflect the reality that
dark passions sometimes lurk beneath
the surface of a situation?

2007 20" x 32.5" Acrylic on canvas

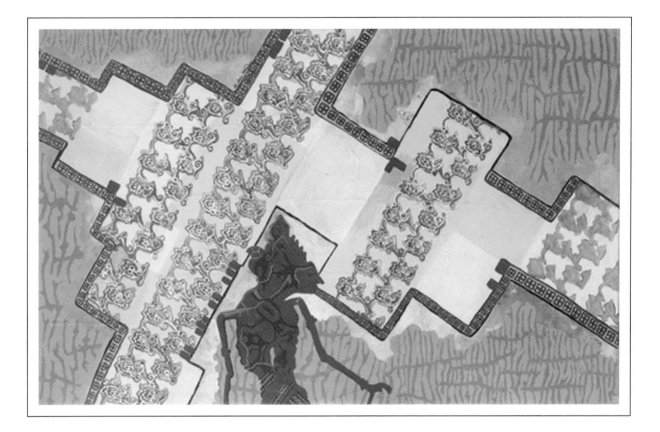

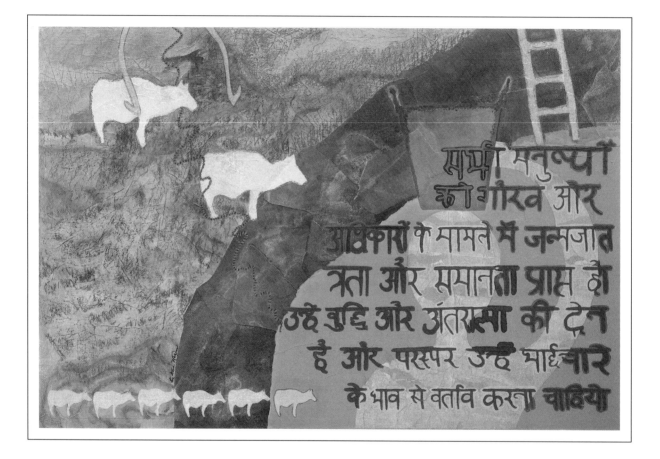

IT'S NOT THE COWS, FOREIGNER!
Kendur, India

"The farmer wasn't careless. You're the one who
left the garden gate open, inviting the cows
to an unexpected feast." I was at fault? Not the cows?
This alternative reality shattered the hypnosis
of western culture. I was initiated into
another way of being.

2008 19.5" x 30" Acrylic/Collage on illustration board

GHOSTS OF THE BRITISH RAJ
Kendur, India

Once a weaving center of 55,000 residents,
Kendur had served all of Asia. Under the British,
village looms were forced to lie idle. Every able-bodied
person went to the fields to cultivate raw cotton for
English mills. Commerce ended. Abandoned by
merchants, Kendur shrank to 5,500 people.

2007 20" x 30"" Acrylic/Collage on Bristol board

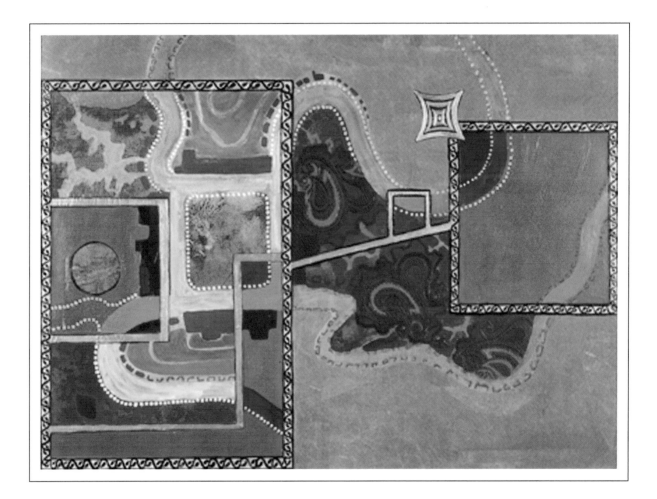

THE MUGGING
Nairobi, Kenya

Five dark figures moved stealthily around me.
One grabbed my shoulder bag as another
struck me on the head. I held tightly to the
straps of my bag as I was dragged along the ground.
My head hit a rock. My fingers released their grip.
I sank into a murky queasy blackness.

2000 13" x 20" Acrylic/Watercolor on illustration board

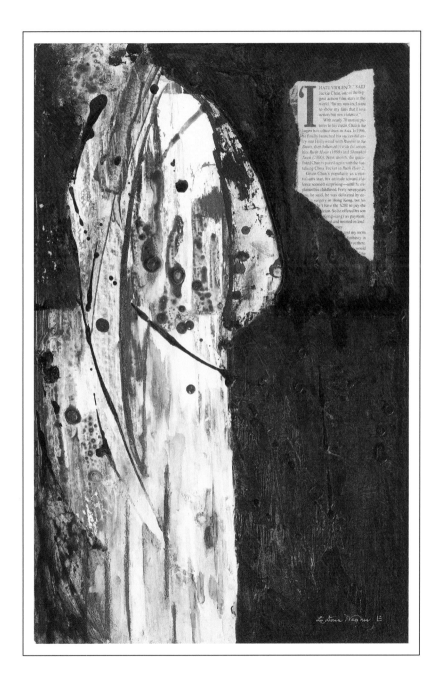

WITNESS

THE ISSUE WAS WATER
Bayad, Egypt

A woman covered in black stood in the muddy canal
lifting a five-gallon water jug to her head.
Two water buffalo defecated a few feet away.
The canal was infested with Bilharzias
organisms that cause lethargy and blindness.
It had inflicted sixty percent of the village's 2,300
Christian and Muslim residents with schistosomiasis.

2006 20" x 30" Acrylic/Collage/Watercolor on Bristol board

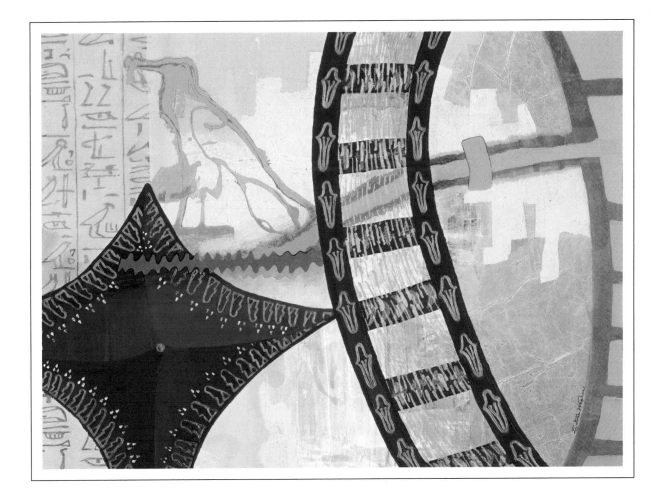

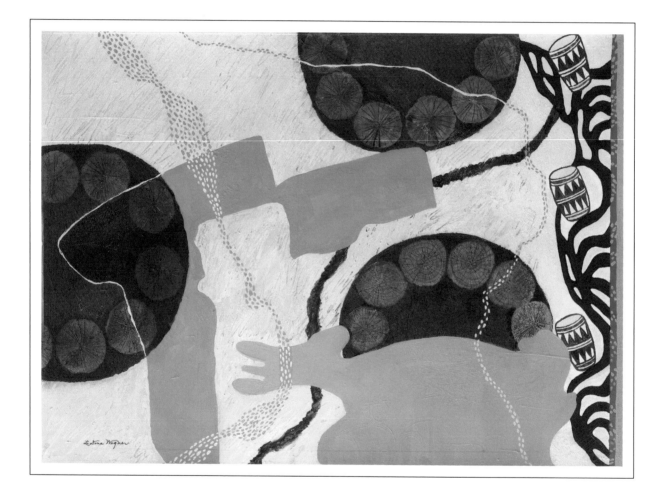

44

GUERRILLAS IN THE GRASS
Shantumbu, Zambia

Dried grass, six feet high and golden in the sun,
dwarfed my five-foot frame. It stretched in
front of me, behind me, and on either side.
Thank goodness I didn't know this vast Zambian
plain was a guerrilla zone – the training ground
for rebels from Mozambique and Angola.

2008 20" x 30" Acrylic on Bristol board

TELLING THE STORY
Darfur, Sudan

As a teenager, Daoud Hari planned to go fight
with a charismatic military commander in Chad.
Ahmed, his older brother, told him to use his
brain, not a gun, to make life better.
"Shooting people doesn't make you a man,
Daoud," he said. "Doing the right thing for who
you are makes you a man."

2008 20" x 30" Acrylic on paper

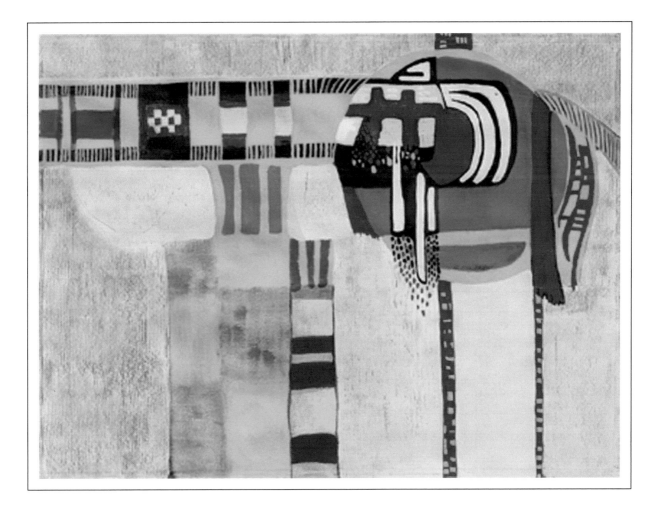

SHARING THE BENEFITS
Nam Wai, Hong Kong

It was an olfactory tsunami, the stench
rolling so powerfully toward me that I nearly
lost my balance. The source of my discomfort
was a pig farm. The farming village, although
rife with clan conflicts, had a history of coming
together to confront common challenges.

2008 20" x 30" Acrylic/Collage on Bristol board

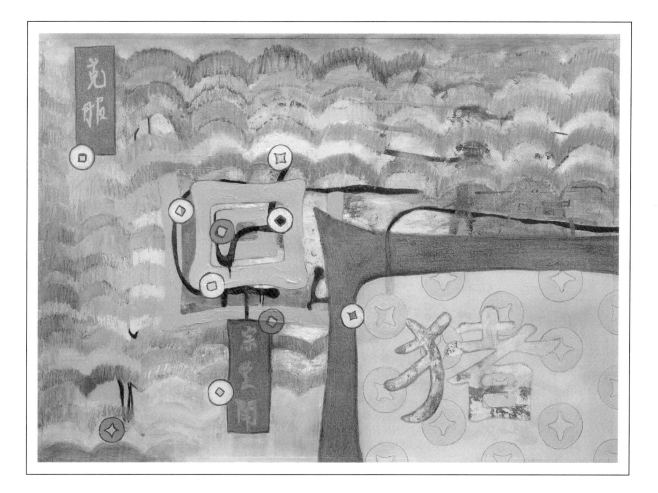

YUBARI MELON TO THE RESCUE
Oyubari, Japan

In May, six feet of snow blanketed Mount
Oyubari, nearly obliterating sight of the deserted
mining village at its base. Within days of the
village consultation, owners of small farms
on the fringes of town began racing toward their
long-held goal of expanded melon production.

2009 22" x 30" Acrylic on canvas

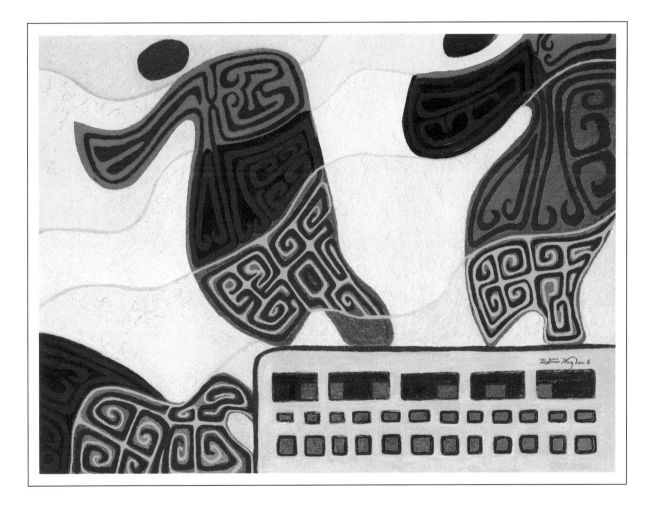

51

BREAKING THE CASTE BARRIER
Maliwada, India

Throughout the night, Chokababa, the old leader
of the Harijans, went around to the houses
in his community, collecting rupee notes from
his people, the poorest of the village,
the "untouchables." Next morning, there was
a knock on the door. As the door opened,
Chokababa held up a tattered handkerchief and
strode forward. Maliwada would have electricity.

2009 22.5" x 30" Acrylic/Crackle paste on 300 lb. Arches

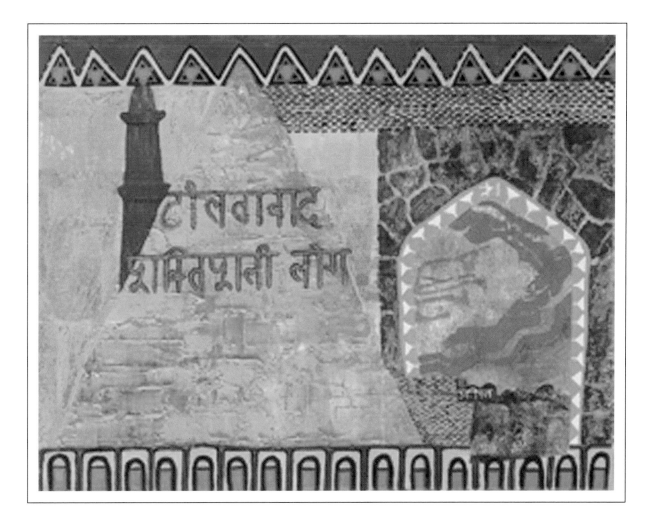

PILGRIMAGE STORIES

WONDER: Entering Lands of Mystery

CELEBRATE THE VILLAGE
Taos Pueblo, New Mexico

The adobe appeared to be all of one piece. Like sensuous folds in a section of cloth, it stretched from the foot of the mountain, around the valley, and up the rolling hills. A pattern of square shapes and slanted shadows made up the centuries-old pueblo undulating beneath this seamless covering.

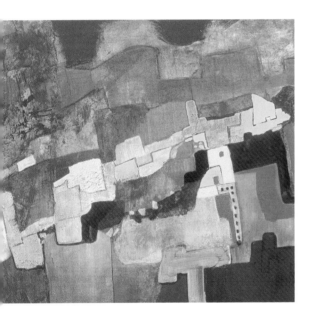

In spite of the ebb and flow of invading peoples throughout the southwest, the people of Taos had kept their community and its traditions alive. Similar to the Aborigines of Australia, Taos Pueblo had maintained a continuous history. What an amazing feat of infinite patience. There was something primordial about this village where I stood in spring of 2003.

I moved about observing the pueblo from various angles until the noonday heat addled my brain. Slowly the sight before me began to dissolve into a flood of memories: crumbling mud brick walls in Kendur, India; mud and stick homes in Kelapa Dua, Indonesia; the honeycomb of clay structures in Bayad, Egypt; a jumble of mud and cement buildings in Ijede, Nigeria; dirt roads in Shantumbu, Zambia.

Taos called to mind my pilgrimage to villages all over the world. I turned and walked through blowing dust toward a bus stop at the edge of the pueblo. Unbeknownst to me, a new series of paintings had been seeded.

detail: *Celebrate the Village*

WALKABOUT: AYERS ROCK/ULURU, BOOMERANG, MEDICINE BAG
Western Australia

Round and round the wheels turned as the train left the outskirts of Sydney and rumbled toward Melbourne. Through the window I saw bleached bones poking up from an endless expanse of barren land. With each rotation of the wheels, I wondered, "How did the Aboriginal people survive for 40,000 years in this environment?"

In Paddington, Old Tom, bushy-haired with soft eyes and velvety black skin, had taken my hand and studied it carefully. Australian friends claimed Tom had walked all the way from Oombulguri, near Darwin, to Paddington on the outskirts of Sydney. That's a distance of two thousand miles.

Staring into my palm, Tom said, "You're fire. Your husband is rock." Knowing our marriage was on shaky ground, I asked, "Is that good or bad?"

"It depends," responded Tom in a quiet tone. "We Aborigines believe everyone is fire, air, rock or water. We need all of these to live. Rock is solid but can be hard to move. Fire gives heat and light but it can also destroy. It takes a lifetime to learn how to handle all of the elements."

Although I had traveled in Africa, Asia and Europe prior to coming to live down-under for a year, I was not prepared for the human wisdom Tom had to offer. It was only years later, after my Western veneer had been scraped away by countless experiences abroad that I understood what this master of harmony with nature had done. He unveiled and introduced me to my character, Fire Woman.

BLESSED RAIN
Sungai Lui, Malaysia

Water showered from above, sparkling like crystals all around us, as we slid on our bums down large smooth stones. Surrounded by thick jungle leaves and cooled by the waterfall, we climbed

detail: *Walkabout*

again and again to make the slide. When lengthening shadows foretold the onset of evening, we wrapped towels around our shoulders, found a barely perceptible path, and headed for the school compound where we were staying. All paths led to the school.

Malaysia had endured British rule, seethed for many years with ethnic strife between Malays, Indians, Chinese, and fought an ongoing battle with communist guerrillas. But here in the jungle northwest of Kuala Lumpur, the people of Sungai Lui village were concerned about literacy and

health care. Rubber plantations, copper mines, and seafaring pirates were nowhere in sight. Instead, we found trees draped with guavas and breadfruit and rice fields shimmering like silver in the sunlight.

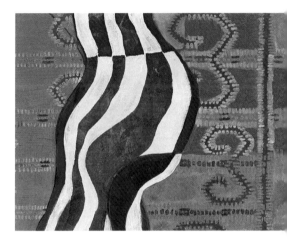

Perhaps in no other place on earth have I felt so strongly the power of nature to heal the human spirit. Unlike the often negative consequences of monsoon rains in the Philippines and India, here in the Malaysian jungle the arrival of the monsoons was welcome. Drenching downpours replenished streams and rivers. Flooding brought fertile topsoil to the rice fields. Here the rains were blessed. Their accompanying verdant growth left me rejuvenated.

BEASTS OF BURDEN
Western Tarlac, Philippines

It was the cusp of the rainy season. Having navigated a slippery road through the lowlands, the bus bumped and careened up a narrow mountain path. I could not justify calling it a road. Traveling in Southeast Asia, I was on a personal quest – to learn from aboriginal cultures before they were extinguished by the westernization that was sweeping the area in the late sixties.

In search of the indigenous peoples of the Philippines, I had wanted to go to Baguio City in the northern province of Ilocos Sur. Time and money kept me closer to Manila so I traveled instead

detail: Blessed Rain

to the mountainous region of Western Tarlac. There the sight of women serving as beasts of burden was seared into my memory. While I was dismayed to see women being used in this way, I was totally in awe of their strength and resilience.

Years later the image of those women returned as I wrestled with disappointment over the slow progress of the feminist movement in the West, and I wrote the poem, *Wind Water Stone*. Another fifteen years passed before the painting *Beasts of Burden* made an appearance.

Wind. Water. Stone.

Tiny red-clad women climb a steep mountain peak.
On their backs, sticks for fuel, water jugs, helpless babes to suckle.
Wind sighs sorrowfully in dark stone crevices,
Step after step,
Day after day.

Wind. Water. Stone.
Layers of rice terraces ascend treacherous cliffs.
Irregular pools of water shimmer beneath the sun, liquid, green.
Raging rainstorms pound painfully raised walls,
Stone upon stone,
Year follows year.

Wind. Water. Stone.
An agonizing march on the knife-edge of existence,
Humanity and rock molded together in an endless dance of creation.
Hunger, despair, mistrust bear down upon the soul,
Doubt piled on doubt,
Moment by moment.

Wind. Water. Stone.

detail: *Beasts of Burden*

60

UNDESERVED KINDNESS
Azpitia, Peru

The tickets to Machu Picchu were sliding toward me but, as I reached under the grate, the dizziness I'd been holding at bay dissolved into blackness. I sank to the floor. Crumpled beneath the ticket window of the railroad station in Cusco, I came to with a couple of young Peruvian men lifting me, one under each arm. One held my purse, the other my tickets. A circle of concerned onlookers surrounded me. As the men carried me to a taxi outside, I began vomiting. They maneuvered me into the decrepit cab, deposited tickets and purse in my lap, and handed me a roll of toilet paper to wipe my face.

The taxi driver adopted a slow pace for getting me back to the small inn where I was staying, stopping occasionally for me to open the door and vomit. Upon arrival, I leaned heavily on him as he walked me into the lobby. After settling me in a chair he went to find the coca tea I'd been advised to drink earlier that afternoon. "It will help your body adjust to the high altitude," the hotel receptionist had said. Anxious to get back to the inn before dark, I had rushed to the train station, ignoring her advice. As I sat limply in a straight-backed wooden chair sipping coca tea, I was well aware that I was an undeserving recipient of considerable human kindness.

This was the conclusion of my third trip to Peru. I had come to train indigenous staff to write funding proposals without the help of foreign volunteers. The coca tea induced a mood of reverie. I recalled my first visit to Peru in the mid-1980s when I'd come to document

details: *Beasts of Burden*

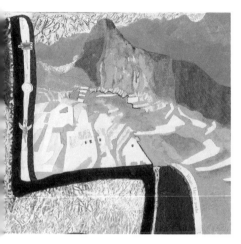

accomplishments of Azpitiia rural development project for a report to funders. An hour away from Lima, the village had totally charmed me with its small adobe homes all painted white, women in clothing made of traditional hand-woven cloth, roads that were swept clean, and small corner stores with canned goods and corn meal. It was right after a two-year drought. The cracked brown earth, dust, and thin air seemed similar to the surface of the moon. It boggled my mind that people could live on a narrow strip of land between foliage-covered mountains and life-nurturing ocean and yet suffer from lack of water.

My second trip two years later had been to help prepare a funding proposal for a cheese factory in Villa El Salvador, a shantytown of 500,000 people on the outskirts of Lima. At that time there was double-digit inflation and political tension. An insurgent group, Sendero Luminoso (Shining Path), had declared war against capitalism and was terrorizing people throughout the country.

Each visit to Peru deepened the awe with which I regarded descendants of the Incan civilization and the last trip was no exception. The stonework, architecture, and setting of Machu Picchu were impressive to the point of being overwhelming. This ancient Incan city, the cohesion of Azpitia village, the determination of Peruvians to carry on despite irrational bursts of violence, and the kindness and compassion of two Peruvian men and a taxi driver in Cuzco engraved themselves upon my soul.

HALF YET TO LIVE
Oaxtepec, Mexico

The deer stood less than six feet away, gazing steadily into my eyes. Moments before, I had watched a sunset of lavender and rose that moved me to tears. Now communing with this gentle doe had me transfixed.

detail: *Undeserved Kindness*

I had worked for the last six months with a local Mexican steering committee, organizing an international human development conference, Our Common Future. Over five hundred attendees had come and gone. Now we were wrapping up details and documenting conference results. Until three days earlier I had no idea that for me, personally, this conference would be a culmination rather than momentum along a continuing path. My work as I had known it was ending.

I moved one step nearer to the doe. She turned and bounded away through roadside bushes. I had broken the spell. Still pensive, I went to sit beside a small pool over which a magnolia tree stood guard. I watched moonlit reflections in the water and breathed in the scents of magnolia, pine, and sage. Overhead the stars were coming out, one by one, in the deep indigo sky, stirring something deep within me. Positioned at the midpoint of my life, I felt an urge to alter my trajectory.

The future was as yet impenetrable. But here in Oaxtepec, this ancient Aztec healing center, I was calm, unperturbed by not knowing what lay ahead, feeling at one with the inexplicable appearance of the deer, my totem animal. For that evening and in that place I accepted that the future, though different than I'd anticipated, would take care of itself.

ENCOUNTER: Meeting Colossal Ogres

WHERE'S THE FERRY?
Ijede, Nigeria

Horns were blaring, fenders were crumpling, Nigerian men were yelling at one another, and my head was throbbing from heat and dehydration. On a two-lane highway, eight illegal lanes of traffic had snarled cars of every vintage into a knot that prevented passage. At each such impasse,

detail: Half Yet to Live

someone at the center of the knot would jump out of his vehicle and direct traffic until cars could once again move. According to the map, this trip from Lagos to the village of Ijede should take forty-five minutes. Five hours and innumerable shouting matches later, our battered dust- and bug-covered auto swerved off the potholed tarmac highway onto a rutted dirt road.

Until two the next morning, village residents welcomed us by pounding on large metal oil drums, dancing with metal ringers jangling at their ankles, and shaking rattles made from gourds. The view from the second floor of the cement structure where we were staying was a swirl of orange, red, green, yellow, blue, and purple. In my demented frame of mind, it looked like an expanding and contracting bruise. When the revelry stopped, the suffocating air was filled with the sound of flying roaches.

In the days that followed, I became helplessly lost in the labyrinth of buildings that made up Ijede. There were mud and stick structures, metal sheds, partially constructed cement homes, and an occasional bungalow. I was informed that the maze-like quality of the village layout was intentional; it prevented outside enemies from being able to find and murder the chief. Organization being my forte and essential to my sanity, I was completely outside my comfort zone.

Ijede was positioned on a lagoon that had once yielded a steady supply of fresh fish. Exploding population and accompanying pollution were decimating this food source. Now a majority of the sons of the village worked in Lagos. Village leaders wanted to create a ferry system on the lagoon that would enable people to get from Ijede to Lagos in an estimated thirty minutes. I vigorously supported this idea.

In truth, had that ferry system existed, I might have used it the day I arrived so I could get to the airport and go home. For the fact was – the vitality, endurance, and imagination of Ijede's people were an assault on my sensitivities. The discomfort I experienced suggested to me that I was not the strong, open-minded person I believed myself to be.

detail: *Where's the Ferry?*

LIFTING THE SHADOW

Kelapa Dua, Indonesia

Wind whipped under the sides of the red and white circus tent, wrenching its poles out of the ground. Awakened by pummeling rain, we raced toward the lifting tent, trying to grab the fabric that had become a billowing sail. We missed. The tent flew for several yards before a pole caught in branches of a tree and several men were able to stop it from blowing away entirely.

As morning broke, the rain stopped and the sun came out. Dazed, we wandered around the area retrieving the reed mats that had formed the sides of our pit latrine and washing areas. We once again raised the tent, reinforcing each pole. After reconstructing the latrine and washing areas, we emptied suitcases and festooned the compound with clothes that needed to dry before they mildewed.

The wind storm launched three weeks of living outdoors in Kelapa Dua (Two Coconuts), Indonesia. During the first week we went from one hamlet of a few mud and stick homes to another several miles away, threading our way along the narrow ridges between rice paddies. With the help of teenage boys who knew a little English, our team of ten foreign consultants surveyed every person to learn the issues for which they were determined to find solutions. Health care emerged as number one.

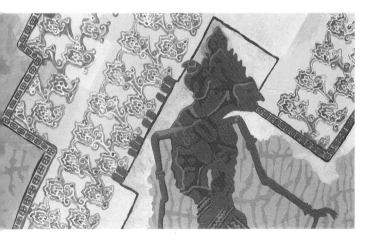

In our fourth week, following a village planning consultation, a few of us went into Djakarta to arrange for printing the project plan that would guide the village's efforts to achieve its vision. I stayed in the home of a teacher at the international school. After living out of doors for three weeks, this bungalow felt like a palace.

A few days before I was scheduled to leave Djakarta, several foreign consultants arrived from Kelapa Dua in the back of a truck. They stopped at the house to use the facilities and then went off to

detail: *Lifting the Shadow*

65

have a few beers. After dark they returned, intoxicated, to wait for the truck that would take them back to the village. By the time the truck arrived, all were sound asleep. I walked among male bodies strung over chairs, couches, and on the floor announcing the arrival of the truck. No one responded. The driver became agitated; he had others to pick up along the way.

After several futile attempts to arouse the drunken men, the driver and I began to gently shake some of them by the shoulder. Suddenly a six-foot hulk rose up yelling a string of swear words and grasped me by the neck. I struggled to break free. He began pressing his thumbs into my throat. Roused by his yelling, several other men pulled him away from me. I collapsed on the floor, gasping for breath. He told someone I reminded him of his mother.

There is so much about Indonesian culture that I love – gamelan music, the monkey dance, batik sarongs, pulsing market days, the official policy of honoring diversity, and the temples at Borobudur. I resonate on a deep level with the Indonesian people and their spirituality. But it's their exquisite shadow puppets that I find especially fascinating. For me, the puppets represent the dark and often hidden side of humanity. They seem such a powerful reminder that lurking beneath the surface of every situation are deep passions emanating from unresolved traumas – dark passions that can erupt when triggered unexpectedly. Some deep inner wound caused a middle-aged man to awaken and attempt to strangle not me, but his estranged mother.

IT'S NOT THE COWS, FOREIGNER!
Kendur, India

Living in the village was a ceaseless round of chores, from spreading cow manure on the floor as a sealer to keep down the dust, to collecting water for drinking, cooking, cleaning, and bathing. One day I was sent to water the vegetable garden, our demonstration of how families could grow nutritious food on a small plot of land. After going to the garden and opening the gate, I took the bucket to the well, about five hundred meters away.

detail: *Lifting the Shadow*

The well was about ten feet in diameter with a protective brick wall four feet high; its inner walls were also lined in brick. Nervous, I let the bucket down too fast. It hit the water with a smash and the handle jerked out. As I stood holding the rope with a handle dangling ludicrously on the end, the bucket filled with water and slowly sank below the surface. Bubbles ceased. Ripples disappeared. A cloud of darkness swallowed me up, as I knew without a doubt that the bucket, a costly and essential item, was now at the bottom of the well, a depth of twenty feet or more.

Nearby, several Indian women covered their mouths, laughing. Mortified, I ran to the project center to get help, explaining my predicament through gesture since I couldn't speak Hindi and the translator was away. A young man returned with me to the well and I pointed to where I thought the bucket must be. He stripped to his briefs and dove to the bottom. Again and again he surfaced and disappeared. At last he brought up the bucket and reattached the handle. I smiled my gratitude.

Slowly, gently, I lowered the bucket, watched it fill. Hand over hand, I pulled the bucket to the top of the well and cautiously lifted it to my head. My self-conscious trek to the vegetable garden ended at the gate, where I stopped in horror. The whole garden had been trampled and two cows stood contentedly finishing off the last of the green beans!

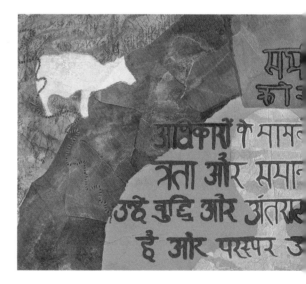

A huge anger swept over me. I was consumed with rage against the cows. Or was it fury against life in the village? I wanted to seize a stick and beat the cows to death. But I was so afraid of them that I set the bucket on the ground and raced down the road, tears of rage burning my eyes. I would get someone to help me teach those cows a lesson they'd never forget. When I arrived at the project center, my Indian colleagues just laughed.

My rage exploded. "How can you laugh about losing our whole crop?" I screamed. "We've been growing this garden for six months and now, in the space of an hour, the whole thing has been destroyed by two cows that some careless farmer allowed to wander off." Our translator, recently

detail: *It's Not the Cows, Foreigner*

returned, made clear that I was at fault, not the cows. "No, the farmer wasn't careless. You're the one who left the gate open and invited the cows to an unexpected feast."

All that day I fumed. Nothing from my university education or family upbringing had prepared me for this event where my perception of "right" was in direct conflict with that of my Indian colleagues. That night I went to bed humiliated and deeply troubled.

Over the days and weeks that followed I came to understand that reality is merely an operating consensus among groups of people. I had stepped into a different consensus, a world as rich and meaningful to these people as the one in which I had lived all my life. All unconscious illusions of moral superiority shattered. The hypnosis of my culture was broken. I was initiated into another way of being.

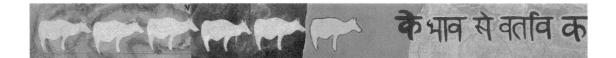

GHOSTS OF THE BRITISH RAJ
Kendur, India

When I arrived in India, I was as emotionally brittle as centuries-old parchment. I was part of a twenty-person international team responsible for launching a grassroots rural development movement in central India. My posting was a village located two hours by bus from Pune.

The bus careened over a rutted road, the sides of which were strewn with piles of scattered mud bricks, the remnants of a once thriving, but now defunct weaving community. Amidst chickens in rickety crates, baskets laden with groceries, and men wearing white dhotis and spitting red betel nut juice, I arrived in Kendur.

detail: *It's Not the Cows, Foreigner*

My living quarters were in a former animal shed that was attached to the back of an abandoned school building, now the project center. An Indian couple lived in the other half of the shed and had to go through my space to get to theirs. The divider between us was a straw mat hung from the main rafter. Two square holes six feet above ground on one wall provided the only light and ventilation. Through these holes, open except for a few metal bars set into the mud brick wall, I heard a constant din of couples arguing, bullock drivers shouting, drunks urinating, and horns honking as bicycles, motorcycles, and delivery trucks trundled by on the adjacent road.

My task was to assist residents in establishing a community garden and a women's sewing industry. That was the plan. What I really did was experience firsthand the aftermath of Western colonial expansion. In the days before the British raj, Kendur had been a bustling town of 55,000 people, a weaving center serving not just India but all of Asia. Under the British, village looms were forced to lie idle. Every able-bodied person went to the fields to produce the raw cotton in demand for the English mills. Without the weaving industry, commerce ended. Merchants locked the doors of their shops and homes and moved away. In 1977, Kendur had a population of 5,500 people, many living in small hamlets out amongst their fields.

Day after day I walked past crumbling structures: a door frame silhouetted against the sky, a pile of bricks trailing into brush, a window frame fallen in the dust. I had known derelict buildings in Chicago's inner city. But I had also seen those boarded up structures renovated with a Housing and Urban Development grant and ghetto residents trained in the building trades as a result. It was clear to me that in addition to new economic ventures, a village reconstruction plan was needed.

But investigations into who owned the defunct properties were a hopeless tangle of bureaucracies that extended over generations. The task of rebuilding would take a lifetime and

detail: *Ghosts of the British Raj*

my stint would be one or two years at most. Despite the beauty of the rolling hills surrounding Kendur and the colorful passionate people I met, the daily sight of miles of ruined buildings broke my spirit.

In Kendur I saw in my own face the reality of the oppressor. I found the devastation wrought by Western culture's blindness unbearable. I felt discouraged and hopeless.

THE MUGGING
Nairobi, Kenya

It was dusk when my friend, her two children and I left the restaurant in Nairobi. We ran across the highway to catch a bus back to our urban project in the shantytown of Kawangware. We were hurrying because we'd been told that it wasn't safe to walk after nightfall.
To get to the bus stop, we had to pass a secluded wooded area.

As we hustled toward the designated spot, five dark figures moved stealthily around me, separating me from the others. Someone grabbed my shoulder bag as another struck me on the head. I held tightly to the straps of my bag as I was dragged along the ground. My head hit a rock. The strain on my arm relaxed as my fingers released their grip on the handles of my bag. Vague shadows melted into the woods as I sank into a murky queasy blackness.

I came to and found my friend leaning over me. Her children were crying. She tried to lift me to my feet. I stumbled slowly upright, dazed. My lip was swelling and bleeding where a strong hand had clamped my mouth shut to keep me from screaming. I had a growing lump on the back of my head. A car stopped. Someone helped me in and drove us to the squatter area where our project staff lived above a saloon.

There was no electricity in Kawangware. My friend used a flashlight to help me climb the rickety stairs up to the staff residence on the second floor.

detail: *The Mugging*

She led me to a dormitory of bunk beds. I collapsed in a heap of bruises onto a threadbare army blanket. I heard the blaring of a battery-operated radio in the bar below.

This was the second time that a bag containing my money, plane tickets and, more importantly, my passport had been stolen. Five years earlier in Pune, India, I had been duped into setting my bag on the ground to wipe supposed bird shit from my jacket. In less than a second the bag was gone. I screamed for help. The police, rather than chase the thief, took me to their station to calm my hysteria.

In India, I had felt stupid and vulnerable, out of sync with the culture, but I had suffered no physical harm. This time, I felt deeply violated. Knowing that tomorrow I must get a new passport, replace my plane tickets, and find financial resources, I felt alone and afraid. I lay sobbing in the darkness.

WITNESS: Beholding Unsuspected Heroism

THE ISSUE WAS WATER
Bayad, Egypt

A woman covered in black stood in the muddy canal lifting a five-gallon water jug to her head. Two water buffalo defecated a few feet away. While water is necessary for life, this canal was infested with Bilharzias organisms that cause lethargy and blindness. It had inflicted sixty percent of the village's 2,300 people with schistosomiasis.

Over the course of a month I had witnessed the illiterate women of Bayad, a village of both Christian and Muslim residents, maneuver around ancient prohibitions against their public participation in decision making so that they could attend a village planning consultation. They were determined

detail: *The Issue Was Water*

71

to ask outside consultants and government officials how to get pure drinking water for their families.

As the consultation got underway, nature intervened. A desert wind caused the men to change the orientation of the red meeting tent. The Egyptian women, suddenly in the front of the deliberations instead of sequestered in the back, took advantage of their newfound position to wring a commitment from government officials to help drill a drinking well in the village. In the months that followed, the women cajoled their exhausted and discouraged husbands to keep turning the hand-operated drill, deeper, deeper, and deeper still – until it reached pure water.

It was 1976. I was discouraged with the lack of opportunities for women within the organization for which I worked. But as I experienced the persistence of these village women, I felt a surge of hope. The courage of Bayad's women became a beacon toward which I moved.

GUERRILLAS IN THE GRASS
Shantumbu, Zambia

Dried grass, six feet high and golden in the sun, dwarfed my five-foot frame. It stretched in front of me, behind me, and on either side. I could not see the person I was following, but watched for where the grass swayed or was slightly bent. I had no idea where we were on this vast Zambian plain or how much further we had to go. The longer we walked, the more I thirsted for water. At last we reached a small clearing, and I sank to my knees.

For the next three weeks, my companions and I lived in a makeshift tent that leaked when it rained and steamed in the afternoon heat. At night we listened to the calls of wild animals, none of which we recognized. One night we were terrified when grunts and footfalls came so close that it seemed monstrous animals were entering the tent. Next morning we found that cattle had

detail: *The Issue Was Water*

passed less than six inches from our tent, eaten our lemon-scented soap, and chewed the sheets we'd left to dry.

Each morning for a week, fifty to seventy Africans appeared under the meeting tarp at 8:00. Most had walked for two to three hours. After taking morning tea and bread, they broke into teams to create plans for health, education, economic ventures, community cohesion, and cultural restoration. On some days teams were taken by truck into Lusaka to make contacts with officials who could assist them. Some days teams disappeared into the grass in search of sites for possible construction. At 5:00, they began the two to three hour return walk to their huts somewhere in the tall grass.

We used a metal tool shed as a workspace for compiling the results of Shantumbu's village planning consultation. It was hooked up to a generator that provided electricity at night so we would have light for typing the village plan using manual typewriters. (I secretly lusted after an electric one.)

Late one afternoon during the week following the consultation, there was a knock on the door. We opened it to find an army jeep, a government official, and four armed guards. The official informed us that we were in the middle of a guerrilla zone. Guerrillas from both Mozambique and Angola used the area as a training ground. Having recently learned of this, the government was rescinding its permission to launch a community development project in the area. We had twenty-four hours to vacate the site.

In the years since I departed this land of red earth, golden grass, and endless blue sky, I have never ceased to marvel at the vigor and hope of the Africans who walked all those miles to create a plan for their future. Many of them knew there were guerrillas in the area but never let on because they so desperately wanted something better for their children. When the project site was moved

detail: *Guerrillas in the Grass*

to another area, Shantumbu tribesmen sent word telling friends and relatives at the new site to participate in the project. They sent some of their young people to be trained and then return to Shantumbu to take up where we left off. The Zambian bush people had a long-term vision that outlasted both me and the guerrillas.

TELLING THE STORY
Darfur, Sudan

Tears were streaming down my cheeks as we sat on small camel saddles in a tent on the periphery of Addis Ababa, Ethiopia. The walls and floor of this locally popular restaurant were

draped with heavy Oriental rugs. Four of us were hunched over a cone shaped basket supported by three sticks. The inside of the basket was covered with thin spongy bread. In the center of the cone was a reddish meat hash, lamb, I think. After a while I resorted to mostly eating the bread, dipped only slightly into the hot spicy stew. Forty-five years later tears would once again course down my cheeks, this time not because of spices but for a very different reason. I was reading *The Translator, A Tribesman's Memoir of Darfur.*

The Translator is Daoud Hari's story of individuals who risked everything to get the truth of Darfur out to the world. Darfur is a desert area of Sudan that is home to indigenous farming and herding peoples who are being systematically wiped out because they occupy oil-rich lands. Hari writes that there are spaces in Darfur where "Mirages make birds sitting on distant dunes – birds no bigger than your fist – look like camels. Mirages make dry flatlands look like distant lakes ... make the bones of a single human skeleton look like the buildings

detail: *Telling the Story*

of a city far ahead. … All trails are erased with each wind. … mountains are not to be trusted … the crunching sound under your camel's hooves are usually human bones, hidden and revealed as the wind pleases."

Hari's older brother Ahmed epitomizes the Zaghawa tribesmen of Darfur. As a teenager, Hari planned to go fight with a charismatic commander in Chad. Ahmed found his younger brother and told him to use his brain, not a gun, to make life better. "Shooting people doesn't make you a man, Daoud," he said. "Doing the right thing for who you are makes you a man." Hari returned to school where he learned English, a skill that would later afford him a means to assist his tribesmen.

After working abroad to support his family in Sudan, Hari returned home. He arrived as Ahmed was preparing their village to escape before an anticipated attack by the Janjaweed. Moments before the assault, villagers began walking to Chad. For the next three months, Hari and six of his friends scouted ahead on camels to find water for their desperate tribesmen. The seven men brought food from Chad and helped people find one another and safe routes. They buried men, women, and children who could not finish the trip. Hari grieved for Ahmed who was killed defending their village.

Seeing the flood of refugees pouring into Chad, Hari began serving as a translator, leading dangerous forays back into Darfur. While accompanying Paul Salopek from *National Geographic*, the two men and their driver were captured, imprisoned, and tortured. Salopek gives a journalist's report of that ordeal in the March 2008 issue of *National Geographic*. In *The Translator*, the storytelling voice of Daoud Hari gives the reader a more graphic and gripping account.

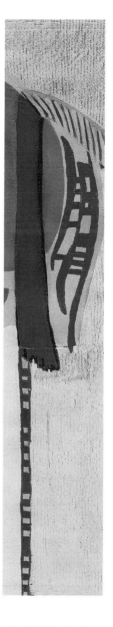

detail: *Telling the Story*

SHARING THE BENEFITS

Nam Wai, Hong Kong

It was an olfactory tsunami, the stench rolling so powerfully toward me that I nearly lost my balance as I entered Nam Wai. The source of my discomfort was a pig farm near the center of this hillside community on Sai Kung peninsula. Despite its smell, the farm was a fine example of sustainable agriculture. The pigs were fed garbage – food scraps from countless restaurants down in Hong Kong harbor. Once fattened, these animals were slaughtered and returned to those same restaurants to become Sweet and Sour Pork, dumplings in Wonton soup, Dim Sum, and any number of other delicious Chinese dishes.

Nam Wai was a former fishing village whose older residents told stories of the dangers they had survived. When fishing gave out, they had become an agricultural community, carrying pigs and vegetables over the hills to market. Now, with the continuous expansion of Hong Kong, they faced a change of zoning from agricultural land to commercial use.

The people of Nam Wai were very hard workers, competent, precise, and with an amazing ability to function with few resources. They endured an environment that was cold in winter and sweltering in summer. They had no central heating or cooling system. Some mornings, it felt as though your blood had turned to concrete. Typhoons were such a common occurrence that a highly evolved warning system was in place. "Signal eight," for example, meant a typhoon with winds at 130 kilometers/hour. The wind would bend the palm trees to the ground. Rain would soak through buildings made of plywood.

Although rife with clan conflicts, the village had a history of coming together to confront common challenges. Years before, they had built a sea wall to harvest salt. During the war they had resisted the Japanese. As they confronted the pending change in zoning, leaders in the community were committed to having everyone gain from the situation. To make that happen, the community worked tenaciously to establish a community foundation for sharing the benefits.

detail: *Sharing the Benefits*

YUBARI MELON TO THE RESCUE
Oyubari, Japan

May on the northern island of Hokkaido was like no other spring I had experienced. Six feet of snow blanketed Mount Oyubari and nearly obliterated sight of the deserted mining village at its base. We cruised slowly down the main street, past one boarded storefront after another.

Despite the appearance of defeat and desolation, there was no doubt in my mind that the people of this community would find solutions to their economic dilemma.

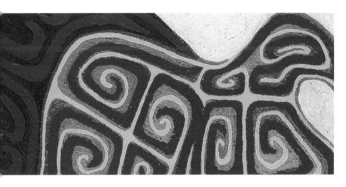

Stunning Buddhist shrines in Kyoto, high-speed trains in Tokyo, Neolithic Ainu artifacts, and contemporary ice sculptures in Sapporo, had convinced me on a trip ten years earlier that this ancient culture was not only aesthetically and technologically advanced, it was disciplined and inventive.

All communities have resources at hand with which to address their issues. Frequently, all it takes is a nudge of some kind for people to access energy and ingenuity that have been allowed to lie dormant. In the case of Oyubari, the nudge was a week-long planning event in spring of 1978. During the event, owners of small farms on the fringes of Oyubari made visits to university research stations, successful farmers in nearby municipalities, and other agricultural bodies.

Within a week after the consultation, six neighbors built a greenhouse. The new greenhouse would serve as a collective nursery for melon plants during early parts of the season and for direct production of melons during the winter months.

These farmers had been discussing building a common greenhouse for years, but it took a week of focused research and discussion for them to take practical action. Invigorated, they picked up

detail: *Yubari Melon to the Rescue*

77

the torch of economic development and raced eagerly toward their long-held goal of expanded melon production.

During the next couple of years, Oyubari farmers increased melon production and joined with other melon farmers in the municipality to successfully brand "Yubari Melon" as a luxury fruit for a nation-wide market.

BREAKING THE CASTE BARRIER
Maliwada, India

Maliwada is a farming village that lies at the base of the hill-fortress of Dalautabad about 16 kilometers northwest of Aurangabad in Maharashtra, India. Once known as "City of Prosperity," Dalautabad Fort had been the capital of the Tughlaq dynasty beginning in 1327. Fifty-meter vertical sides at the base of the fort and a narrow access bridge made Dalautabad relatively easy to defend. Muhammad bin Tughlaq moved the entire population of Delhi to this area. After two years, Tughlaq abandoned the city for lack of water. Population drifted away and the area fell into disrepair.

In the late seventies, the people of Maliwada elected to become a demonstration village development project. Having lived for centuries under the shadow of former greatness, they chose an image of the sun rising over Dalautabad as a visual symbol of their commitment to change.

One of the early projects undertaken by the village was getting electricity. They set a deadline for themselves to have electricity connected by Diwali, the annual fall festival of light. A delegation of villagers went into the government office in Aurangabad to request the extension of lines into the village. The group returned that night with word that electricity was possible but they would have to make a deposit in Indian rupees equivalent to US $150. For residents in this

detail: *Breaking the Caste Barrier*

78

depressed rural community, that was a huge sum of money. Electricity seemed out of reach. People felt dejected.

One man was undeterred. Chokababa, the old leader of the Harijan community, took matters into his own hands. Throughout the night, Chokababa went around to the houses in the Harijan community, collecting rupee notes from his people, the poorest of the village, known as the "Untouchables." Next morning, there was a knock on the door of the project staff residence. When the door opened, Chokababa held up a tattered handkerchief. He strode forward and, placing it on a table, untied it to reveal a great mass of one rupee and five rupee notes.

Other people from around the village were called together and shown what had been collected in the Harijan community. As the rupees were counted, excitement rose. While not all that was needed, the necessary deposit was in sight. Inspired by the commitment of their poorest members, other village leaders went door to door in the rest of the village and collected enough additional money to make the deposit. Another trip to Aurangabad secured the needed certificate. Maliwada had electricity in time for Diwali.

No longer abandoned, the village at the base of Dalautabad Fort became a place of refuge and inspiration. Across Maharashtra, rural villages were steeped in caste customs and sunk in inertia from centuries of municipal neglect. During repeated visits to Maliwada, people from other villages witnessed the community's cooperation among its castes. Maliwada became a light that showed the way to others.

detail: *Breaking the Caste Barrier*

LIDOÑA WAGNER

LiDoña Wagner is an active exhibiting artist who uses acrylic and mixed media to create narrative abstractions that vibrate with saturated color and innovative symbolic shapes. Wagner's art documents victories of the human spirit and evolved through following the European model of apprenticing with master painters. Her work stands in the tradition of Wassily Kandinsky, Helen Frankenthaler, Joan Miro, and Judy Chicago.

Attuned to the many cultures in which she has lived and worked, Wagner's work has the feeling of textiles hand woven by indigenous craft persons. To achieve her active textural surfaces, she uses knives, nut picks, plastic scrapers and sheeting, hand pressure, razor blades, sandpaper, brushes, as well as layering of personally painted papers. The color and symbols so obvious in Wagner's work come from a lifelong passion for working with dreams. She enhanced her knowledge of symbols by working with Jungian analyst Miléne Baron in Brussels, Belgium.

Wagner's paintings hang in private and public collections in Australia, Canada, Egypt, Mexico, and United States. She has had over a dozen solo exhibitions and been represented in more than twenty competitive shows. Articles on her artwork have appeared in *American Artist* and *Palette* magazines. She is listed in *International Who's Who of Professional & Business Women*, *Art: Twenty-Ten*, and Ask Art's *The Artists' Bluebook*.

Also a writer, Wagner integrates narratives into her visual work. Her *Inner Journey* column ran for five years in *FOCUS* magazine in British Columbia; and she is a registered consultant in the Intensive Journal process of Dr. Ira Progoff. She holds a master's degree in Literary Nonfiction from University of Oregon in Eugene, where she currently resides.

"The Pilgrimage series shown here emerged from a global quest during

which I was tested to the core of my being and found meaning in

coming to know the cultures that make up our world.

I am currently at work on Children of Eve, a series of paintings that trace

our ancient human journey out of East Africa to all corners of the globe."

LiDona Wagner

PHOTO CREDITS

PART I

Page 3
Left to right:
Robert Roberts of Western Australia - **Teresa Lingafelter**
Field work in Bontoa, Indonesia - **Phyllis Hockley**
Girls collecting water in Bayad, Egypt - **Tim Wegner**

Page 4
Young boys' initiation in Mowanjum, Western Australia - **Mimi Shinn**

Page 5
Photos of Western Australia, clockwise from top:
Boys learning the "Pigeon" dance in Mowanjum - **Mimi Shinn**
Site of Oombulgurri planning consultation - **Teresa Lingafelter**
Boy writing on oil drum - **Elaine Telford**
Oombulgurri Primary School - **John Burbidge**
Ronald and Doris Morgan of Oombulgurri - **David Zahrt**
Center: Eddie Eura - **Adrian Laurie-Rhodes**
Background: Oombulgurri landscape with Boab trees - **David Zahrt**

Page 6
Photos of Indonesia, clockwise from top right:
Woman in Bontoa, winnowing - **Phyllis Hockley**
Boy in Kelapa Dua getting water - **Tim Lush**
Preschool in Bontoa - **Phyllis Hockley**
Women in Bontoa, harvesting; Man in Bontoa, carrying water; and *Center:* Men in Bontoa, planting rice - **Len Hockley**

Page 7
Girls during spring in Oyubari, Japan - **Pamela Bergdall**

Page 8
Women going to church, residences, and weekly market in Kawangware on the outskirts of Nairobi, Kenya - **Terry Bergdall**

Page 9
Photos of Peru, clockwise from top right:
Cracked earth from drought in Azpitia - **Kip May**
View of Azpitia village from highway - **Judith Hamje**
Boy and dog in Azpitia - **Kip May**
Preschool of Lunahuana Project - **Gloria Santos**
Woman weaving - **Postcard from Cuzco**
Health fair festival in Lunahuana Project - **Rocio Torres**

Page 10
Women getting water from well in Bayad, Egypt - **Tim Wegner**

Page 11
Photos of India, clockwise from top left:
Maliwada celebration, Interior arch of Dalautabad Fort, Maliwada women's event, and Maliwada project staff residence - **Bruce Robertson**
Background: Dalautabad Fort - **Wikimedia Commons**

Page 13
Maps – **MapCruzin.com**

PARTS II and III
All photographs of LiDoña Wagner paintings by **Walt O'Brien**

82